Annie Poon
The Split House

Writ & Vision
274 West Center Street
Provo, Utah 84601
801-647-7383

This catalogue accompanies the Writ & Vision gallery exhibition, Annie Poon: The Split House, curated by Glen Nelson, opening June 3, 2016

© 2016 Glen Nelson, "Annie Poon: The Split House"
© 2016 Annie Poon, all images
All rights reserved. Published in the United States of America
All images courtesy of the artist and Writ & Vision

cover: El Sueño, 2016

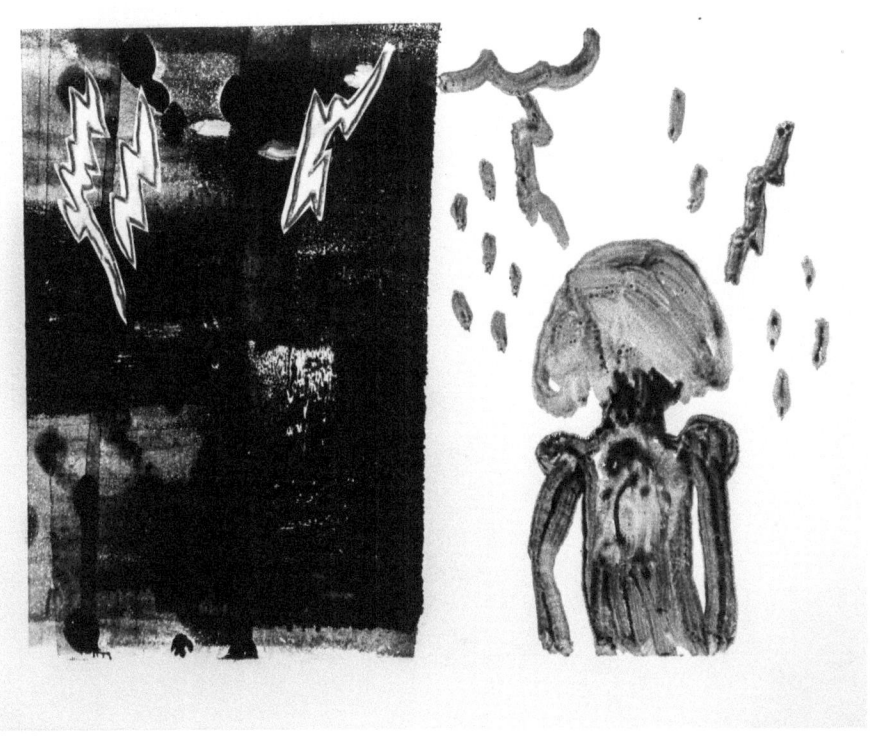

Lightning and Rain, 2016

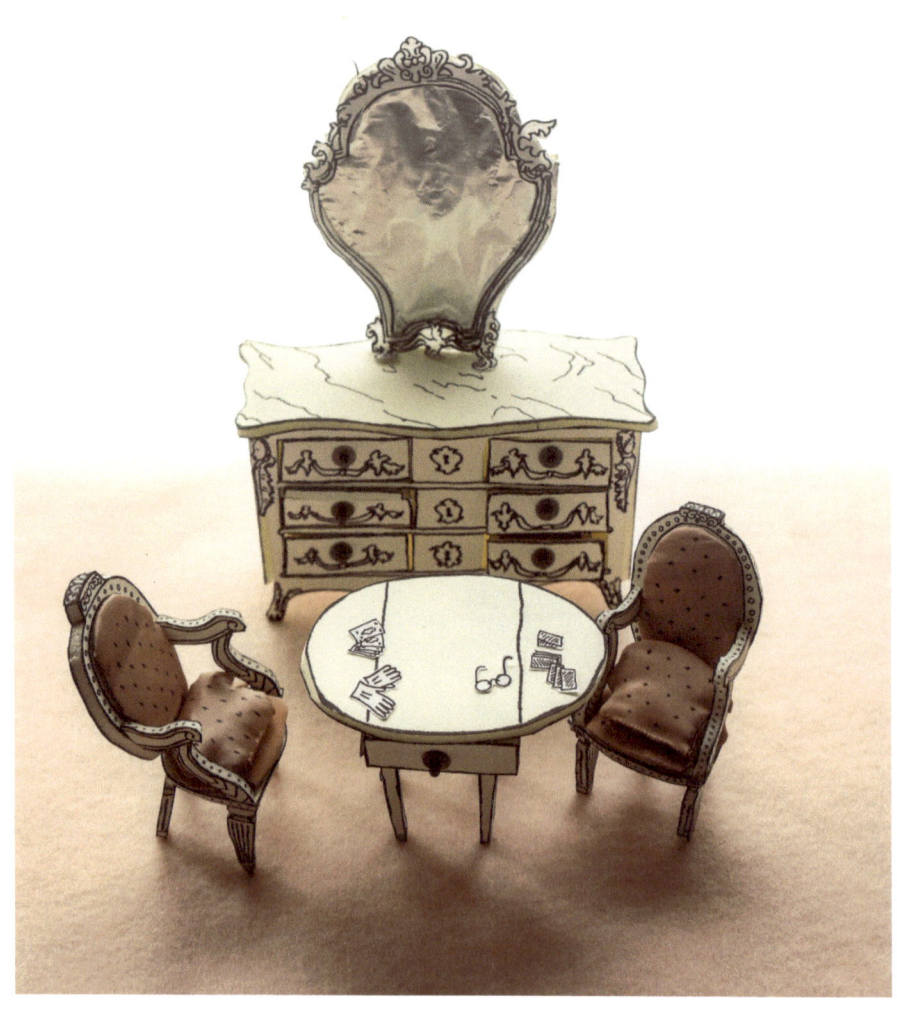

A Rubber of Whist, 2011-2015

Annie Poon
The Split House

Glen Nelson

Introduction by Brad Kramer

Writ & Vision
Provo, UT

Black and White Is a Subject in Itself
Brad Kramer

"My sketchbook is the stage."—Annie Poon

Inspired by one of Mormonism's most formative and poignant sacred texts and participating in a long and rich LDS tradition of representations of struggling prophets, "Thou Art Not Yet As Job" (2015) is a work which engages all of the key themes—aesthetic as well as spiritual and philosophical—of this show. The gaunt figure easily fulfills any viewer's expectations for depictions of Job, so it likely takes a moment for the surprising truth to register: this is not Job, but rather Joseph Smith, Mormonism's founding prophet, in ruin on the floor of a Missouri jail cell, while his flocks are violently scattered and he awaits what he can only assume is his trial and execution. It is jarring to see the prophet like this, mostly on aesthetic grounds: this is, to my knowledge, the first depiction of him with a beard (a feature surely present during the months while he waited for the trial which never came).

Annie Poon is one of the most prolific and widely recognized fine artists the Mormon tradition has ever produced. She is a master of her craft, and while the media she employs are impressively variable and diverse (drawing, printmaking, painting, sculpture, sound composition, and of course animation), one of her creative constants is her choice to treat Black & White as "a subject in itself." Sparked first by the sheer force of the visual contrast, she has pressed the aesthetic binary into the service of carrying deep philosophical water. Glen Nelson, whose inimitable curatorial work with the artist has produced a show any gallery would be honored to present, teases out how black and white overlay onto death and life in his interview (printed below) with the artist. Their conversation focuses largely on the animation (which provides the title for the show itself, *The Split House*), and also explores other dualities: of personality and identity, of disorder and healing.

The animation ties the rest of the works of the show together, but

perhaps nowhere is this more vivid than in Annie's sobering and somewhat surreal depiction of the suffering prophet. An owl is present, watching Smith's agonies as a wise and protective spirit. Is this the owl the artist herself transitioned into during the therapeutic healing of the animation? Here, in Liberty Jail, the contrast of black and white sets into stark relief the other great duality: good and evil. "Thou art not yet as Job" is part of the answer the Lord gives to the slowly dying prophet's indignant petition, his invocation of what is known commonly as the Problem of Evil—how can a Being this loving and powerful permit the suffering of so many? The context of the image calls the mind to the third key theme of the show, with which the aesthetic (light and dark) and spiritual (death and life, good and evil) binaries triangulate: Time.

Time is death. Time erodes and corrodes, adds more death to death. Time also heals, animates death with new life. Time is therapeutic. Time is dual. In the show we encounter it most obviously, if symbolically, in the clocks. But it is relentlessly present throughout the works of the show, steeped as so many of them are in the trappings of their own process. This is especially true of the animation, which not only must occur in and over time to even be encountered but also represents time. The stop-motion bespeaks the laborious hours of creation, literally a decade of time in the life of the artist. To animate and to be animated is to be in time. And, per Glen's incredibly insightful essay, to animate is to give life, to vivify, to make alive. It is the mystery that underlies all mystery, all magic. It is creation and creativity. To say that *The Split House* is a show that centers on its eponymous animation is both technically true and misleading. The show itself is an animation in that it *animates*.

—Brad Kramer
Writ & Vision
Provo, Utah 2016

Bringing the Dead to Life:
The Alchemy of Stop Motion Animation
Glen Nelson

Take a lump of clay and breathe life into it. This is the quintessence of creation. From the Latin derivation, to animate is to instill with life. What are the elements of transformation for an animator?

Soft clay, or a cloth puppet, a piece of chalk drawing on a blackboard, a line on paper, connected photographs, a flipbook, a motion picture: artists make something from nothing. They transform materials. You could say the same about any creative artist. These are intertwined exercises; and yet animation as an art form is different, somehow.

A sculpture can be lifelike, with every human muscle perfectly rendered in plaster, stone, or metal, every proportion accurate. Still, no one views a classic bronze sculpture in a museum, however great it is, and thinks it is alive. It is strange but true that a much more crudely constructed, pint-sized clay figure, with only 4 fingers on a hand, no subtlety of movement, incongruously colorful skin, and with little verisimilitude of any kind can, if only briefly, *seem* alive. You know it can't be, but for a second, your brain wonders. And that is the magical moment.

What is this process of seeming? Motion has a lot to do with it, but there is more. How did early animators use the emerging technologies of their day to provide the fleeting sensation that an inanimate thing can move and breathe?

Magicians going back centuries—at least to 1550 and likely much earlier—wowed their audiences with the blow book. Are you familiar with it? Here's how it worked. A book's pages are shown to the audience. The sheets appear to be blank. Then, after an audience member blows on the book, the pages are again shown, which are vivid with images. (There are many variations on the blow book. In one, the pages are at first in black and white, and then are transformed into color. In another, the pages are black and white; then color; then become blank.)

To Kill a Mockingbird, 2015

Mansfield Park, 2015

The illusion is accomplished by having different sets of images printed on paper cut at the outside margin irregularly, on a slight angle, for example. The audience's eyes are tricked into thinking that all the pages are the same dimensions. But by placing the finger that flips through the book high or low on the outside edges of the book, the illusionist can force the book to flip two pages at a time, thereby showing a chosen group of pages, the blanks, for example, to the exclusion of the others. If the finger is held in another position farther down the margin, different groups of pages are revealed.

The blow book is magic at its most basic. It is visual transformation that upends expectation. Add a storyline, and you have a flipbook. Photograph it, and you have animation. Combine it with live-action characters, and you have film. Throw in $100,000,000, and you have a Hollywood CGI, sci-fi summer blockbuster. (Well, theoretically you do.) In all these examples, the media differ, but the magic is the same, conceptually.

It is extraordinary to look back at the milestones of early film and stop motion animation, in particular. (Stop motion is exactly what it sounds like: an image is created and then captured in some way; another image is created; and they are linked together on film and shown sequentially. That's its most basic formula.) One would think that the science from a century past would render the surprise ineffective to modern eyes, but it doesn't. The mind still wants to believe, and the artistry comes through loud and clear. The following is a short timeline:

1887 – Eadweard Muybridge publishes *Animal Locomotion: an Electro-Photographic Investigation of Connective Phases of Animal Movements*. It included 20,000 photographs of movement, captured by banks of cameras and then edited to display movement. (Muybridge created a device to show motion pictures called the zoopraxiscope that pre-dated Edison, below. But the shift in photography toward moving pictures was in the air. Concurrently, Etienne-Jules Marey coined the phrase chronophotography and built a camera-gun that captured 12 consecutive frames per second.

1891 – Kinetograph (a motion picture camera) is patented by Thomas Edison and designer W.K.L. Dickson. Viewers looked at the film through a peephole of a device called a kinetoscope, which was popular in arcades. Edison made current events films. These included recent sports moments and political affairs. A viewer dropped a coin into the slot and watched, say, one round in the latest championship boxing match. If the viewer wanted to see the next round…that would take another coin.

1894 – Mutoscope is invented by Hermann Casler. A popular attraction in penny arcades, the machines mounted Muybridge images to a wheel and when spun, gave the illusion of movement.

1895 – Lumiére cinematograph (film projector) is first shown.

1890s – Pre-cinema, optical toys abound in the years between the invention of photograph and the moving picture: Thaumatrope, Phenakistiscope, Zoetrope, Praxinoscope, and flipbook-related items under a variety of names, folioscope, kineograph, living pictures, pocket cinematograph….

1896 – Kinora is invented by Auguste and Louis Lumière. It was a handle-driven machine that mechanized a flipbook on a picture wheel.

Shortly before the turn of the century, pioneers of cinema began to make their first creative efforts. Art met science. Among these were artists who employed techniques that paved the path for animation. (By the way, nearly every one of the films listed below is available for viewing to anybody with access to YouTube. Do yourself a favor and watch these works, many of which are very short—all of which are amazing.)

1896 - *Le Manoir du diable* (The Haunted Castle) by Georges Méliès. This is an early, 3-minute film of people appearing/disappearing. Méliès was a master of early cinema. Of his 500 films, approximately 200 survive.

1901 – *L'homme a la tête en caoutchouc* (The India Rubber Head) by Georges Méliès. A disembodied head (of the filmmaker) seems to expand and contract by blowing air into it like a balloon; ultimately, the experiment goes too far, and the head pops.

1902 – *Fun in a Bakery Shop* by Edwin S. Porter and Thomas Edison. A frazzled baker sees a rat climbing up the wall and then throws wads of bread dough at it. He starts to create bas-relief sculptures with the dough on the side of a wooden barrel, in quick succession, of gargoyle-like portraits. No motion, per se, but quick-changing images. The spit-take of flour at the end is sort of genius.

1902 – *Le Voyage dans la Lune* (A Trip to the Moon) by Georges Méliès. In the film, a group of astronomers make a plan to travel to the moon. Limited stop motion elements, most memorably, the rocket poking the man in the moon in the eye. This film fantasy, like many of the era, is strongly influenced by the novels of Jules Verne.

1906 – *Humorous Phases of Funny Faces* by J. Stuart Blackton. This is the dawn of hand-drawn animation. Blackton creates a funny film of moving chalkboard drawings.

1907 - *The Teddy Bears* by Edwin Porter. In a pattern that would be repeated for a century in cinematic dream sequences, a stop motion animation goes where realistic filmmaking cannot. In this six-minute satire of Teddy Roosevelt that updates the story of Goldilocks and the Three Bears and ends with Roosevelt killing the adult bears, a short sequence shows Goldilocks peeping at a performance of acrobatic teddy bears. It is just over a minute in length but required over 50 hours to animate. Produced by Edison.

1907 – *The Haunted Hotel* by J. Stuart Blackton. This is a film about a tourist's wild night in a magic inn, was a huge success, and it was copied and studied around the world.

1908 – *Fantasmagorie* by Emile Cohl. This animation is indebted to Blackton featuring stick-figure-like characters.

1911 – *The Insects' Chrismas* by Ladislas Starewicz. This one is quite extraordinary: a six-minute film about a man who decorates a holiday tree for creatures of the forest.

1917 – *Romeo and Juliet* by Helena Smith Dayton, the first woman animator. This is an experiment with clay stop motion, her first film.

1928 – *Steamboat Willie* – Walt Disney and Ub Iwerks (cel animation). It was the first Disney cartoon with synchronized sound.

Hunt Piece, 2015

The Oak Wood, 2015

1930 – *The Tale of the Fox* by Ladislas Starewicz. This is his first full-length (62 min.) film, released eight months before Disney's *Snow White*. It is like a pop-up book that springs to life. It's interesting to note the legacy of animation artists who came from (and continue to work in) Eastern Europe. These include: Jiří Trnka, Bretislav Pojar, Kihachir Kawamoto, Ivo Caprino, Jan Švankmajer, Jiří Barta, and Galina Beda.

1933 – *King Kong* by Merian C. Cooper and Ernest B. Schoedsack, with stop-motion sequences of Kong created by Willis O'Brien. In this Hollywood blockbuster, audiences were terrified by O'Brien's rendering of the ape. His earlier short films were set in prehistoric times: *Birth of a Flivver* (1915), *The Dinosaur and the Missing Link: A Prehistoric Tragedy* (1916), *The Lost World* (1925), among them.

1933 – *Footlight Parade* (sequence by Lloyd Bacon and Busby Berkeley). This is a film with a scene in which James Cagney takes playing cards and flips through them, creating an animation of a boat on the water. Also, Berkeley's famous overhead dance extravaganzas are legendary. Essentially, he is creating the effects of animation with those overhead shots in films without stop motion.

1945 – *Vánoční sen* (English version, A Christmas Dream, in 1946) (Zeman Brothers). In this film, a discarded old toy thrown away on Christmas, as a girl gets new toys, comes to life (*Toy Story*, anyone?)

A full analysis of the first half-century of animation is a book-length topic, but even a cursory overview like the above illustrates the rapid development of animation and its embrace in popular entertainment. Moving toward the 21st century, when every desktop computer is a potential animation film studio, the trajectory of stop-motion animation splintered. Commercial film continued to use animation for special effects. Who can forget the skeleton battle in *Jason and the Argonauts* (1963) by Ray Harryhausen, the "Animagic" of Arthur Rankin, Jr. and Jules Bass's *Rudolph the Red Nosed Reindeer*? Claymation? Or the majestic Imperial Walkers from *Star Wars: The Empire Strikes Back* (1980) (stop motion sequences by Phil Tippett)? But there was also a nostalgia for films that were clearly and completely handmade, like *A Grand Day Out with Wallace and Gromit* (1990) by Nick Park.

Ghandi, An Autobiography, 2015

The Story of My Life by Helen Keller, 2015

The discussion of technology and film animation often focuses on the creation of the images and storytelling, but at least as significant today are the breakthroughs that affect an animation's distribution to the public. If every electronic device is a tool for animation—yes, there's an app for that—it's also a fact that the barriers for an animator to have their work seen by others have practically disappeared, creating an entire world of opportunity.

What are the avenues open to animators to show their own work right now? Each traditional venue—the film festival, the museum or gallery exhibition, broadcasting, for example—have been democratized. Is there a phone in your pocket? It's its own film festival. Video-sharing websites, artists' websites, social media sites, and tools to share large data files (because digitized film is still a data-heavy medium): all of these allow and encourage the easy, almost effortless dissemination of animation to the public.

What this ease of distribution does not guarantee, however, is the magic audiences experienced in 1895 when the Lumière brothers' cinematograph was exhibited to the wonder of Paris or when Albert E. Smith and J. Stuart Blackton made *The Humpty Dumpty Circus* in 1898, or when King Kong scaled the Empire State building with Fay Wray in O'Brien's 1933 film sequence. That enchantment is still artist-driven.

Art is innovation. It's easy to think that it is propelled by technology, and particularly in cinematic history, inventors' influence in film is hard to overstate. But the transformation, the surprise, the alchemy of one thing becoming something else that makes the mind believe in the impossible: that is still the domain of the artist.

Black and White: Annie Poon
Interview between Glen Nelson and Annie Poon, March 9-23, 2016

Glen: Hello, Annie. I've watched your new film, *The Split House*, and I am eager to ask you questions about it, but at the same time, I don't want to destroy its sense of mystery and wonder by trying to label each of its components, right?

Annie: I am always excited to talk about my inspirations and the meaning of my work, but I have found that being explicit in my interpretation can really take away from people's enjoyment of the mystery, like you said. I'll try to be somewhat general about the details but also give specifics about my philosophies, etc.

Glen: Maybe there's a middle ground, a way of describing the richness of the film without laying it bare. I am content with the process of gradually deciding for myself what it means, but I'm curious to know what your art means to you, if that makes sense, and how a viewer can maximize the experience of it. Sound good?

Annie: Sounds great.

Glen: You have created 30 films to date. Still, few of your other works feel as personal as *The Split House*. It begins with an answering machine recording, and a female voice says your name. I can't think of any of your work that references you so directly. Or am I wrong, and are you in all the films in one way or another?

Annie: I would say that whenever you see a girl, it is me or my twin sister. I am horrible at guessing what another person might do or think, so I only really feel confident when I'm exploring my own memories instead of someone else's story. I think my character appears in most of my

films, even if you don't recognize her. But you are right, in *The Split House* I'm exploring things that make me or others a bit uncomfortable. In this film I'm bringing up unresolved personal issues, things that have left indelible footprints all over my brain that just won't come off no matter how much scrubbing. That is really a first. I am a bit worried about what my family will think when they see the video. This video is so important to me and such a personal milestone. It has really been made in secret and is also full of secrets.

Glen: Is being a twin, for you, like having a split identity?

Annie: I like to joke that Katie is my evil twin. She has always been tall and dark, while I am shorter and fair. Katie is elegant and stately, and I tell people that next to her I am like a mushroom. We definitely have the twin vibe when we are together. It's not exactly like a split identity but more of a contrast.

Glen: What is the connection between this film and your own history? At the beginning of the video, in particularly, are you the girl?

Annie: Yes. That's me. This film is a little memoir and a glimpse into my future.

Glen: She is clearly troubled—sad, but I suspect it goes beyond that. She is going to a woman for help. A clinical, therapeutic session begins this journey. Of all the scenes in the film, this is the most specifically connected to time and place. Would you like to talk about that?

Annie: One thing I love about having taken ten years to complete this video is that the characters and places over time have become archetypes. They have taken on multiple meanings. "The Split House" refers not only to the city, Split, Croatia that appears in the beginning of the film but also to the state of the split mind and even the split family—the bipolar brain at war with itself.

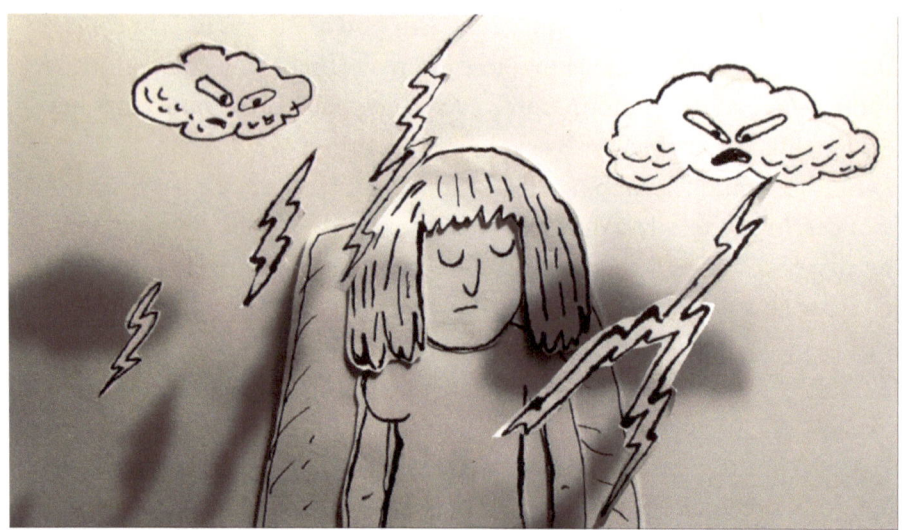

The Split House (animation production still) 2016

Glen: Tell me about the city of Split.

Annie: This city Split, where I served my [LDS] mission, is very special. It's in a region called Dalmatia across the Adriatic from Italy. My grandfather was born not far away in a small *selo*, or village. There is something very beautiful about the stone walls in that region; I include them in the film. Outside the villages you see circular walls of stone piled up around the olive trees. The farmers found the ground too rocky so they moved all the rocks into these little circular walls. They make me think of crop circles. In the small Connecticut town where I grew up, there were also interesting stone walls running willy-nilly through the forests marking the old property lines where the settlers lived. Same story there, just a place too rocky to farm. The remaining walls are like the bones left from an old civilization.

 Another interesting thing about Split that made it magical: it is the remains of the Roman Emperor Diocletian's palace. Most of the city is within the crumbling palace walls. So cool that it is still inhabited and you can see the Roman remains.

 The town I depict in the opening scene is reminiscent too of one of

my favorite children's books, *Strega Nona*, by writer and illustrator Tommy DePaola. Strega Nona was a good witch in a small Italian town who cured the townsfolk's ills with her magic. I have mixed the two towns together visually.

Curiously enough, this film begins with me visiting the home of a healer. Her home is inspired by the home of a convert on my mission who lived in just such a place—a beautiful, snug home at the top of a stair. Her name is Srdana. I dedicated this movie to her. The healer resembles both Srdana and a woman named Karen who also practiced healing in my life where I live in NYC—both, with beautiful curly black hair.

Tied to a time? I would say no, it is a day that I live over again and again—always seeking healing, always seeking health.

Like many artists I have had my share of plaguing mental health issues. It is something that has progressed over the years, a confusing journey from one symptom to the next accumulating like the stones around the olive trees. And as in the film, my health seems to grow darker and more complicated over time. The only way I felt safe talking about this in detail was through the poetic passages of *The Split House.*

Glen: To me, this struggle of mental health appears in the film in the duality of characters who are white/black, female/male. When the owl, which is white, looks into a pool to see reflection, it is black; later, as she is grabbed by the octopus, she turns alternately black and white; she is rescued by an alter-ego owl, who is black; then in a bat-fight, she turns into a man, briefly; and especially, this split identity is apparent when the owl meets the beast at the beginning of her journey, who is literally divided in halves—one side of the body is black and the other half is white. All of these strike me as metaphors of this troubled state of mind. Am I misinterpreting?

Annie: That is one part of it. But there are some other possible interpretations, too. Who is it that in the puddle's reflection? Is it her opposite? Her doppelganger? Her twin?

And one thing I haven't mentioned to this point is my love of black and white. It's a big part of the subject matter—just that visual contrast. When I was in high school I saw a bizarre cult classic from 1980 called *Forbidden Zone* by Richard Elfman with music by Danny Elfman performed by Oingo Boingo. It's in the same vein as *The Rocky Horror Picture* show but more twisted. In it, a man falls down their basement stairs into a new dimension of black and white mayhem. The sets were geometric black and white, suggesting hell and the coexistence of good and evil. That film influenced the look of *The Split House*. Another film in black and white that influenced the look of this film was an eighties stage production of *Alice in Wonderland* where all the costumes were made out of paper and literally drawn over with cross hatching to look just like John Tenniel's original black and white illustrations. So black and white is a subject in itself.

Glen: Another of your films that seems related is *Annie's Circus* (2008). In that work, a woman living in Manhattan, who looks into the mirror and sees only a skeleton as a reflection, goes through her day numb to her surroundings until mermaids in Central Park give her a ticket to the circus. Under the big top, she sees the flying acrobats, turns into a bird herself, and flies away—all set to the haunting Coldplay song, "Lost?", performed by Chris Martin.

Annie: That film is also double-sided. To the viewer it might appear that the skeleton is a threatening presence. It follows her about from the moment she wakes up and sees it in the mirror. There she is, already a skeleton in the looking glass. But to me, the skeleton represented a welcome friend, the chance of comfort in knowing that our time is always near, something better lies just on the other side. I was thinking of Seurat's painting of friends picnicking in the park, "A Sunday Afternoon on the Island of La Grande Jatte," also of Manet's "Le Déjeuner sur l'herbe."

Glen: But it's an ambiguous ending, isn't it? Doesn't it hint at suicide?

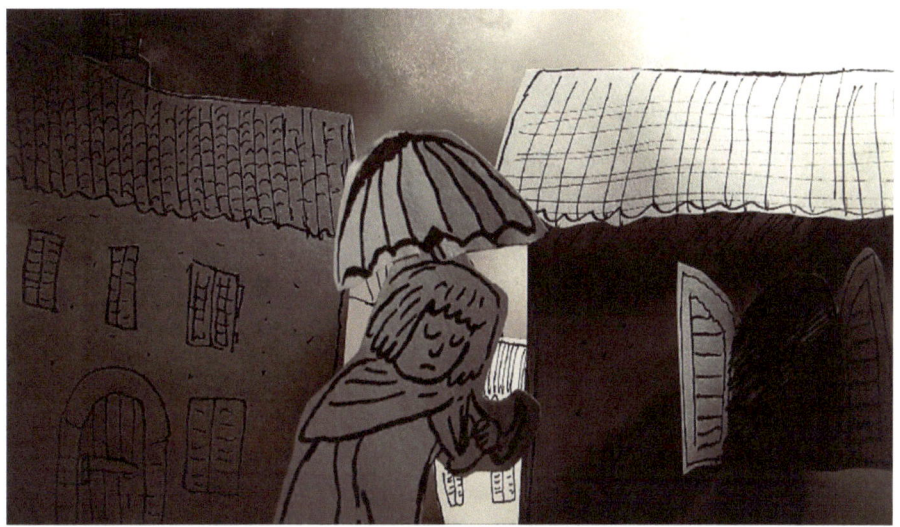

The Split House (animation production still), 2016

Annie: Yes it does. It could be that she slipped from the clothesline at the end, it could be that she transformed into a bird. Both bring her freedom.

Glen: Ten years working on *The Split House*? I can't imagine that any stop-motion animation is quickly made, but why did this require so much time?

Annie: It took time to film, yes. I did need to re-film the first half when HD came along, and I had to make it match the new format. But the thing that took the most time was just letting it brew and become a real presence in the background while I worked on my other films. Eventually things in my life piled up until I had this release in writing a long visual poem about it. Unlike my other films, I didn't storyboard very much on *The Split House*. It was an interesting meditation and revealed itself bit by bit. After re-filming the first half, I just put it on the back burner until I had absolutely nothing left to do but give it my full attention. I had to arrive at a sort of punctuation mark in my life to do it. This gallery show, this moment: it was time.

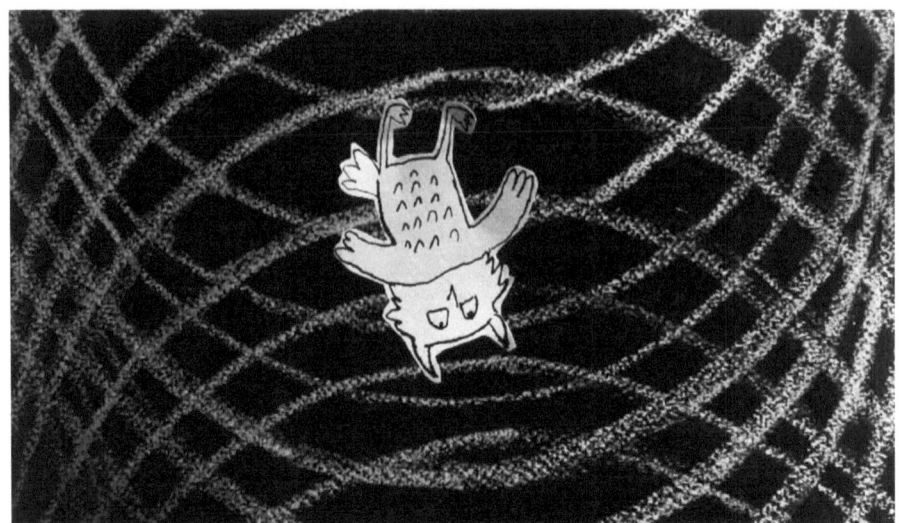

The Split House (animation production still), 2016

Glen: When people see your films, I bet that their first impulse is to imagine how you do it. Isn't that the most common feedback you hear from people seeing your work for the first time? On one level, it's all right in front of our eyes—the materials, the drawn figures, the lighting, the sound, the movement captured on film. You seem to be asking us to join in the making a film because of the transparency of your process.

Annie: Yes, the imperfections are meant to be inviting. People's first question is always, "How much time did it take?" My usual answer is that I can create five seconds of a film in a day. But with this film there was no normalcy. It just sort of came out on its own time. Stop motion is unique to watch, I think because the viewer is always distracted by wanting to total up all the effort, all the cutouts, all the little movements and progressions. They don't really think about that so much with live action. It's funny, when people express amazement at the time commitment, I just think, "Everything we do takes time. A clerk slaves away for more hours each day than I do," but nowhere is it really recorded like in a stop motion film. I like that each film is memorial of time well spent.

Glen: And you seem perfectly happy leaving things just messy enough for the viewer to see your hand in its creation.

Annie: Yes, I like my films to be drawn rather quickly. They really have no polish. It's both disarming and inviting. Also there's so much improvisation and play here. Even in the most haunting passages, it's raucous fun to do. I could stress over certain imperfections but I have no desire to deliver a product like *Toy Story* where every flaw is attended to. There's a level of trust I am extending by allowing things to "all hang out."

Glen: Improvisation? I guess that makes sense, but I've never thought of it before in the context of your filmmaking. In a process as deliberate as stop motion animation, what does improvisation mean? Is it just embracing the happy accidents, or are you looking for chances to go off-script, visually?

Annie: For this film there was no script. That is why I say it was improvisational. I was at times walking the owl across the stage without knowing where she was going or who she would encounter. It was an exercise in stream of consciousness, like journaling.

Glen: Let's take a single, five-second sequence as a proxy of how you made the film. About 90 seconds into the story, doors open in the owl's forehead and she falls into her own mind. That's the action. How was this falling sequence accomplished? There's a background, an owl figure, layers of sound, and lighting. Can you describe your studio setup and walk me through the process of creating these five seconds of film, in detail?

Annie: What a fun question. But it takes a lot of explaining. For the studio setup I have an Ikea table to work on. I line up all my cutouts in order to the left of my camera. In this case I used only one cutout figure of the falling owl. All the drawings in this movie are done with an unpre-

dictable calligraphy pen to make nice line variation. My sketchbook is the stage. I just lean the tripod on two legs over my desk at a precarious angle and pray I don't knock the third leg and have the camera fall over. To achieve nice shadows, I put the light very low to the table off to the right. It's just a clip lamp.

This falling scene was a combination of three scenes filmed at different times. First, I animated the zoom-in to the owl's forehead. I took my first shot of the owl's head, then I drew the door on the owl's head and shot that. I cut the door open. I slowly opened the doors shot by shot. Then I had to use teeny tape loops to keep them from springing closed as I was trying to film. I use zillions of little tiny loops when I film. You can't have things flying about! So here I have the zoom-in shot just getting as close as I can to the owl without blocking the light with my camera.

Next, I filmed separate red dots on a piece of plexi. The dots look like they are dancing, but I was just shifting the plexi for each shot so the dots look rearranged.

Finally, I filmed the scene of the owl falling down the rabbit hole. I was able to give the illusion of the owl's long fall using a rather short piece of paper. I drew intersecting arcs on black construction paper using a makeshift compass. When I filmed, the owl didn't really move from its spot. You will notice now that it was always in the center of the screen. What moved was the chalk drawing beneath it.

The paper incrementally rises, and when I ran out of paper, I lifted the owl and just slid my black paper down again and continued. I never moved the owl from the middle of the scene. In fact I drew a dot on my viewfinder to make sure she was always there in the center. But I just touched her gently and rotated back and forth with each shot to convince you she was alive and falling. She was barely even moving. I could have been gradually sliding the background design upwards or downwards; it wouldn't matter. The viewer has already decided that the owl is falling downwards. It's a great trick when your shooting space and materials are too short and you can't do traveling shots.

Finally to marry the three shots in Premiere [video editing software], I imported it to the computer and inserted each sequence onto its own layer

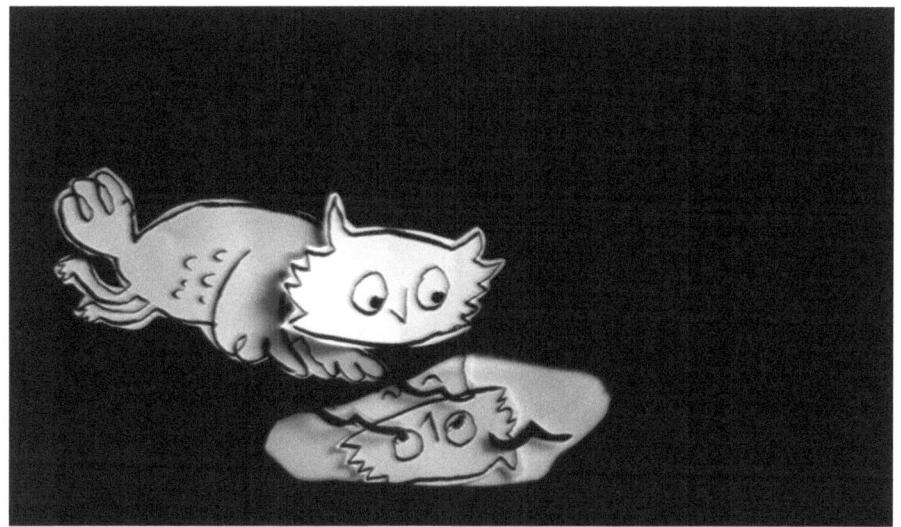

The Split House (animation production still), 2016

in the timeline. I overlapped them slightly and just dragged the "cross dissolve" effect to the ends of each line or scene. The final result was: The dots were dancing, the doors opened on the owl's head, and the owl fell.

Glen: You've forgotten something. What about the sound? I was surprised to learn how much of the music and sound effects in your films are your own creations.

Annie: I love sound design. For me, the movie's success depends upon the music. The song in the falling passage is called "India Beeps." I don't have much of a voice, but I can talk and hum so that's what I work with. I used voice to create rhythmic sound loops. They are edited in GarageBand. My favorite part of the score is where the squid is defeated. For this scene I quoted from one of my favorite passages from the Book of Mormon, 2 Nephi 4:20-22. It reads:

> My God hath been my support; he hath led me through mine afflictions in the wilderness; and he hath preserved me upon the waters of the great deep. He hath filled me

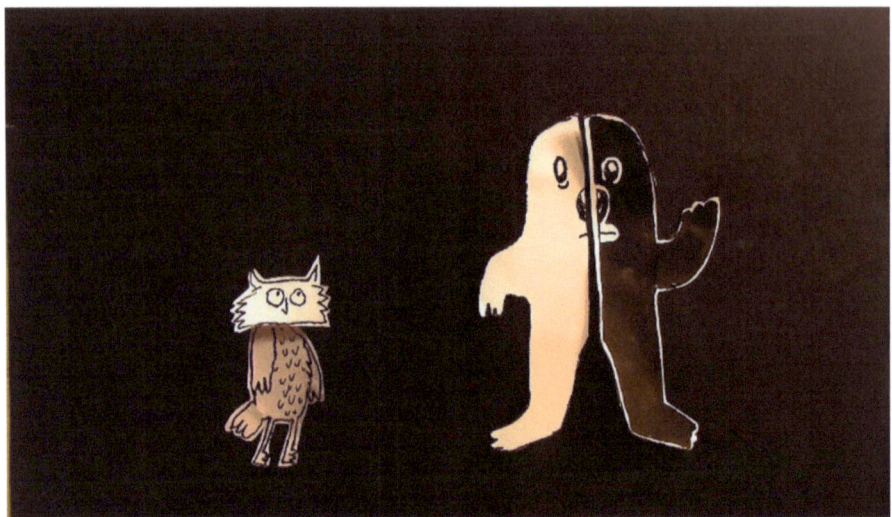

The Split House (animation production still), 2016

 with his love, even unto the consuming of my flesh. He hath confounded mine enemies, unto the causing of them to quake before me.

 I recorded myself reading these passages, then chopped them into pieces and made this unsettling soundtrack.

Glen: You said, "My sketchbook is the stage." It's literal because you are actually shooting film by pointing a camera at the sketchbook from above. What if we could look at your sketchbook for *The Split House*, what would we find there?

Annie: It would be hard for me to say where to look for all those bits of paper. Since the movie was made piecemeal over the years, I have elements scattered across several sketchbooks and folders. But the last few scenes are neatly contained in my most recent sketchbook. In my sketchbook you would see cutouts taped onto their backgrounds, and little squares of cellophane with markers indicating paths. I mark these up and tape them over my viewfinder to organize complicated motions.

Glen: As I watched *The Split House*, I saw emotional echoes from your other films. The old house reminded me of *The Roly-Poly Pudding* (2002), the undersea creatures recalled *Runaway Bathtub* (2004). There are some macabre elements like in *Tis the Night of Halloween* (2002); mysticism as in *The Book of Visions* (2005). You've included elements of humor too, although not to the extent of *Christmas Tree* (2003), *Puppy's Valentines Day Biscuits* (2009), *Oh Puppy!* (2011), or *Daisy Daddy* (2015). There's violence, romance, morality and social commentary that brought me back to my experiences watching *Die Wicked Die* (2009), *In Love* (2002), *The Shiny Bicycle* (2013), and *Paper Doll* (2004), respectively. Am I incorrect to think that *The Split House* is something of a summation of your work, to date?

Annie: I think I used everything that I know in this film. It surprises me to watch it and see the range of moods all squashed into five minutes. But it doesn't feel rushed to me. She seems depressed, then psychotic, finally the end has a feeling of bliss. I do think this film represents me best. One thing I like about *The Split House* is the feeling of hope at the end. I'm very happy with that.

Glen: When I go to the movies and really look closely at the way they are constructed, the least interesting moments are the cuts between scenes. For me, the opposite is true of your works. The transitions are simply magical. Transformation itself becomes a recurring idea. Can you walk me through some of the transformations in *The Split House* and how they developed?

Annie: Yes, I think transformation is a main theme. When she visits the healer they both need to apply their innate wisdom to the situation to understand and connect to each other. They already know the answers deep inside and so they turn to that inside wisdom transforming into owls. This owl is a protector and a guardian. It also appears in the drawing, "Thou Art Not Yet As Job." The Holy Ghost is always there, peeking in on us and maintaining a quiet connection.

I also wanted to include a little nod to a quest video game I used to play on the very first Mac computer. Do you remember *Dark Castle*?

Glen: I don't, but I just Googled it. Mark Pierce and Jonathan Gay created the game about a quest to defeat a dark knight for the Lisa computer in 1986.

Annie: It was a delightful game in black and white. There is a scene where the protagonist has to navigate her way through a cave full of blood-sucking bats. I have always wanted to replicate the mood of that scene from *Dark Castle*. I did that in one of the final scenes here where the owl is drifting through the darkness in the bat-ridden cave. She transforms into one of my first inspirations, the protagonist from *Dark Castle*. There are a couple of black and white video games for the early Mac that inspire my art. I love these games because just like in this movie, in our lives we are going from level to level, conquering and solving one problem at a time. Each scene presents a challenge and some possible threats. After the bat cave, she transforms back into her human form and her boat slides back into our dimension through a cut I made in the paper. This was a complicated scene to shoot and involved me slicing the boat into little pieces to obtain the illusion. Here the guise of the owl is no longer needed; she has come to her own conclusions. Now she drifts in the water, reliant on a higher power to do with her what it will. I love that she is able to completely give up the reins and be scooped up by the many hands.

There was a moment in my past after a relationship had ended that left me in spiritual darkness. After crying in bed for days, I knew my own plan just wasn't working. I remember kneeling and praying, saying "God, I will go wherever you want me to go, do whatever you want me to do, please just tell me what you want." It was a moment of repentance and turning myself over. It felt so wonderful to just give up my will completely. There's a similar feeling in this scene where she drifts under the water. That feeling of letting the bottom fall out from underneath you is frightening but thrilling. Then the final transformation takes place on the

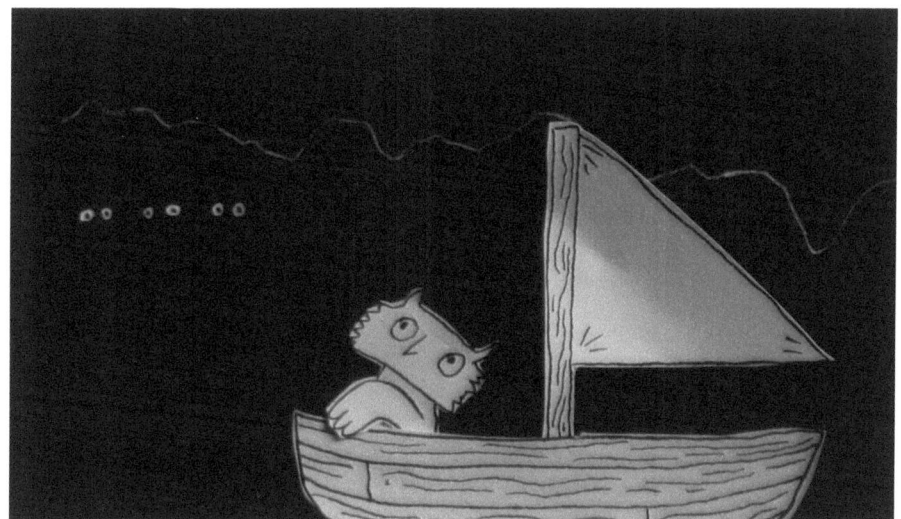

The Split House (animation production still), 2016

ship when two women take her and dress her, as if for her final role. She is the figurehead. This final scene incorporates cues from one of my favorite books, *The Voyage of the Dawn Treader* by C.S. Lewis. In this book the dawn treader literally sails to heaven. She becomes a part of that story when she is grafted onto the ship as the figurehead.

Glen: Let's explore influences. You've alluded to a few already. I respond warmly to your vocabulary of "favorite" things—be they early computer games, books, or fine art. Maybe that's a more useful phrase than "influences." I suspect, looking at your work, that some additional favorite things are Alexander Calder's Circus, William Wegman's dog videos and books, *Jason and the Argonauts*, children's TV segments, etc. Can you name some of the creations that have been meaningful to you?

Annie: My first real influence was a short I saw on *Sesame Street* when I was a little girl. Someone animated a little ring of pebbles dancing in a circle around a construction paper pond. It was done in stop motion. I'm still fascinated remembering the animated clay splashes the pebbles caused when they hopped into the water after their little dance. It was so

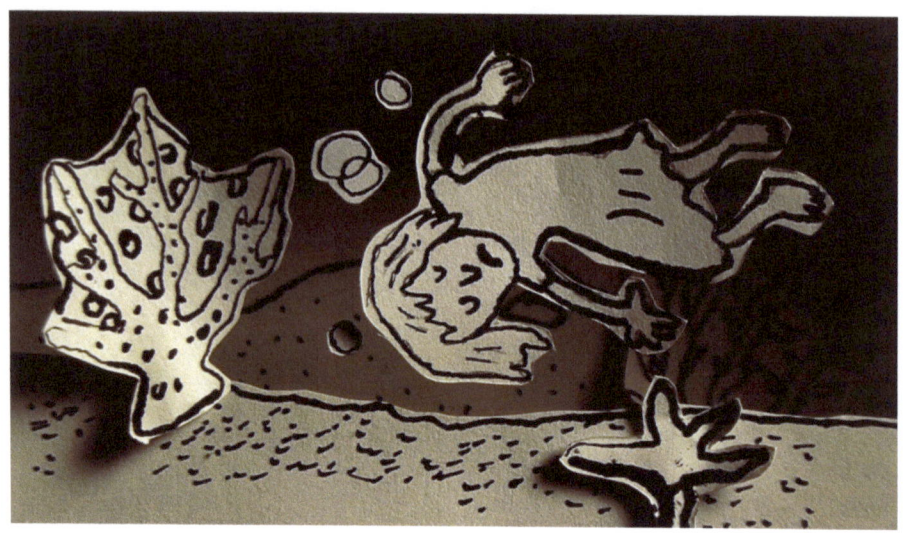

The Split House (animation production still), 2016

simple but effective. I hope my animations are like that—just a few elements, animated with a very random spur-of-the-moment feel. I also love the *Sesame Street* shorts where they introduce new letters or numbers in each episode. They were made so quickly and are so bare-bones. It doesn't get any simpler than that.

There were also endless MTV spots where you just saw the MTV logo in between segments with some creative coloring or vibrations, very punk and exciting. Those little mini-pictures were part of the inspiration for my *Die Wicked Die* animations. As far as fine artists, my favorites are outsider artists like Henry Darger and Howard Finster. I like their bodies of work in part because of the stories behind the pictures. They were both total weirdos who just did their own thing. I like to imagine Henry Darger holed up in his attic creating artwork that he never showed anyone, working as a janitor by day. Another touchstone for me is the work of Nellie Mae Rowe. She created some really strange dolls that really inspire me. For me the moral of all this work is to investigate myself and think about what makes me an individual. What is my story and how am I different? That's what I want to explore.

Glen: Your work is in the collection of the Museum of Modern Art, you studied painting at the School of Visual Arts in New York, and your films have been shown in numerous fine art venues. They fit there. At the same time, I can imagine them pairing easily with outsider art, too, on display next to Bill Traylor, for example.

Annie: That's a cool connection and a huge compliment. Outsider art makes me shiver with happiness. I get to visit the best outsider art fair here each year in SoHo. Those visionaries inspire me because no two outsider artists make the same type of images. I look at someone like Frank Jones who created spook houses of "haints" (haunts or ghosts) when he was in prison. I look at tramp art. These people were really making do with what they had. Using chicken bones or matchsticks to sculpt, or mashed up bread. Indian ledger drawings are also some of my favorite works of art.

Like these artists, I like to limit my materials and force myself to make do. I like the challenge of using only scissors, pens, and paper. It's what was available to me as a kid before I could afford real art supplies. I try to honor my inner child when I approach a new animation.

Glen: How do you interact with these favorites as you are creating a new film? Are they inspirations or is it more than that? Do you quote from them?

Annie: I try not to think about my references while I'm working. It's fun to research things in my free time, but there is no need to be looking elsewhere when a project is underway. We've each lived enough of our own life to have something unique to say without relying on references too much.

Glen: In an interview given to Theric Jepson of *A Motley Vision* in 2012, you said that when you are making a new film that's personal (as opposed to commissions and commercial work), you close yourself off and have little contact with anyone outside of home, for months, up to a year.

I can't imagine that. Why does that work for you, and how does isolation inform your filmmaking?

Annie: Ultimately that didn't work. I had to take a pause from art after that lifestyle led to a breakdown. I was working twelve-hour days, which is just too much for someone like me. It was recommended that I limit my working hours to six per day and actually go out with friends. Since doing that, my work hasn't suffered. Now I try to make time for my husband and home and have other hobbies. It's a great way to give more dimension to your work, to have odd hobbies. I like writing music and short stories in my free time. I also make time for things like crochet, embroidery—things that my mom used to teach us sisters when we were young. You have to have lots of fun to make fun art. My sister Taylor and I are in a little band in our free time. It really lifts and fleshes out my work to have odd hobbies and learn surprising new things. I don't love art about art and try not to just "navel gaze," as they say.

Glen: The current exhibition at Writ & Vision contains sculpture, film, painting, drawing, and printmaking. And all of these objects are recently made. At some point, we should probably stop talking about you as an animator and just say "artist," right? There's a lot more going on than one medium. Are they all connected, different sides of the same coin?

Annie: I have always thought of myself as an artist, starting when I was three and my mom gave me a blank journal to scribble in for family home evening. She would have me draw a picture and explain to her what it meant. Then she would write my words above the drawing.

When it comes to my different styles of art, I don't make an effort to tie things together. I trust that viewers will find their own connections because after all, one person made them.

Glen: And we haven't even mentioned Puppy. Who is he and what makes him tick?

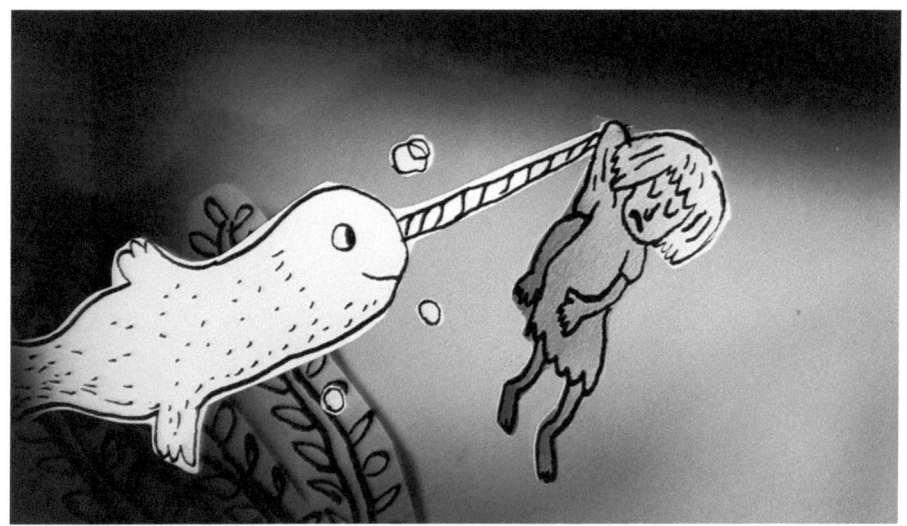

The Split House (animation production still), 2016

Annie: Puppy is my little alter ego. He's a comic cartoon character that I started drawing many years ago. Now he's the subject of my graphic novel, *Oh Puppy!*. He's a spunky little guy always stuck in some new mania. I love to see the world through his eyes. Whenever I vacation or see something new, I wonder how Puppy would see it. Puppy's first adventures took place here in New York. He was constantly chasing down love in the form of a Miss Duck. In my large painting, "The Peeper's Woe," his crush has gotten so out of control that he is bedridden. Who hasn't been there? I have created three animations based on Puppy: *Daisy Daddy*; *Puppy's Super Delicious Valentine's Day Biscuits*; and *Oh Puppy*. Right now I am working on two coloring books about Puppy. In one he visits Bali, and the other one is a surf through the different holidays and a general introduction to his world.

I'm very lucky to have shown Puppy in museums such as the National Gallery, the MAD museum, and the New Museum in their Family Films projects. Children love Puppy!

Glen: When and how did Puppy first appear?

Annie: I think it was around ten years ago. I had been drawing pictures of

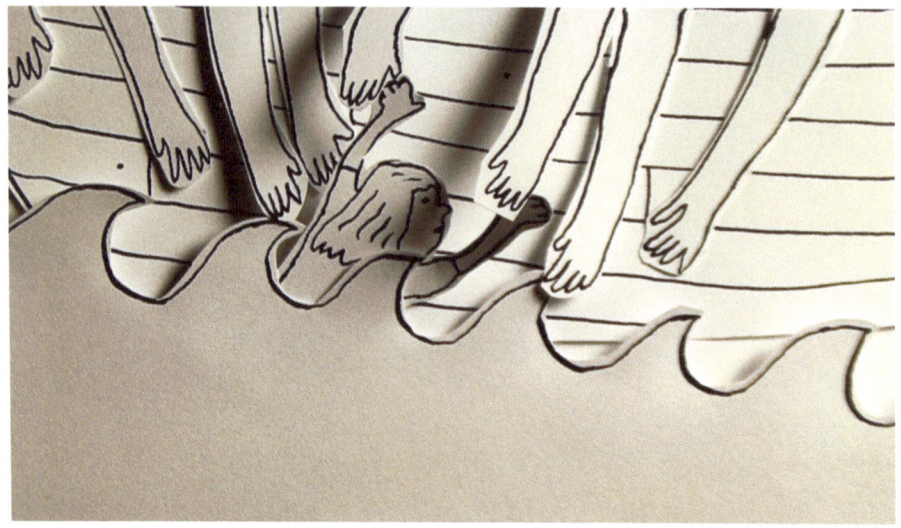

The Split House (animation production still), 2016

my little niece, Grace. She was just a few years old. Her legs were spindly and she had a soft little belly with kewpie doll eyes. I was drawing her in a bunny suit. That character in the bunny suit translated directly into the creation of Puppy. That's one of his favorite guises. My friend Keith Carollo saw the first Puppy cartoons, "Puppy and the Spell" and "Puppy under the Big Top," and he invited me to create a serialized comic on his store's website, Fred Flare.com. The rest is history. That comic became my graphic novel, *Oh Puppy!*.

Glen: If introspection and memory are parts of your work, surely fun and humor share equal billing. How is art joyful to you?

Annie: Whether it's about breakdancing turtles or depression, animation is always a joyful experience for me. I only create somber animations once I've come through safely on the other side. The reason I got into animation was because my husband wanted me to do something that reflected my fun-loving side. At the time I was still a senior in college and was making conceptual paintings. He absolutely hated them and challenged me to find something to do that better reflected my goofy person-

ality. So my first animation was about us kissing (*In Love*). It was actually from a flipbook I made in the corner of my sketchbook. I just filmed each little sketch and made an animation out of it. In this way I became hooked to the video camera and changed the tone of my work. I didn't paint for many years after that, and when I came back to it, it was with this fun playful attitude. Without allowing for my whimsical side, my work could get heavy-handed and boring.

Glen: I doubt that. The first work of yours that I ever saw was the short film, *Christmas Tree*. Somebody at our church near Union Square played it, as I recall, at the end of a religion class on a Sunday. I will never forget the experience. The people in the room were utterly transfixed by it. They were gasping for air, laughing, amazed at what they were watching. Many of these people would never step into a museum without being coerced, and here they were looking at art of the highest caliber and "getting it." Since then, I've tried to parse out the experience. Why did they love it so much? Can any art be embraced by anyone under the right circumstances?

Annie: That animation *Christmas Tree* had some new inventions in it. I was inspired by the dollhouse my parents built for Katie and me one Christmas. We would prepare the dollhouse for Christmas by stringing it with twinkle lights and adding a tiny tree. In the morning we would find Santa had left the dolls candies on the little plates. To really convey that I was playing in the dollhouse, I filmed my hands drawing the scene then manipulating the objects that came out of the tiny paper trunk. To my knowledge that was the first time that technique had been seen, the technique of seeing hands drawing and playing on the screen. It was in 2002. Now 14 years later, the style is well known, as people all over the world use it. I think that technique is what surprised people so much. Also the intimate nature of the movie, the preciousness of all the little pieces of paper in my hands, the simple soundtrack of a five dollar wind-up Christmas ornament I bought a few blocks from my house—all these things contributed to the success of that animation. When I made that

animation art I don't think it wasn't really seen as art, just a cool experiment. I think it was easy for people to embrace because it was so informal. It's one thing to see artwork in a gallery. But seeing it at church or in a children's program takes the edge off.

Glen: A final question: getting back to *The Split House*, you said that the film is memoir and a glimpse into your future. At the end of the film, the girl is rescued and then becomes a figurehead of a mighty ship. She becomes art, permanently installed on the bow for all to see. I read that in some Western European cultures, people believed that these nautical sculptures were inhabited by little men, leprechauns, which the Dutch call *Kaboutermannekes*. These faeries protected the ship and her sailors; further, they guided fallen sailors to the Land of the Dead. If *The Split House*'s figurehead points to your future, where is she going?

Annie: In my imagination she will lead the boat through the fjords into the land at the end of the world where sea and sky meet. It is a great green land of many children where the sun always shines. She will gently lead others on their way, helping guide and direct without controlling them. She will wear beautiful clothing and become a gracious goddess. She will be a mother.

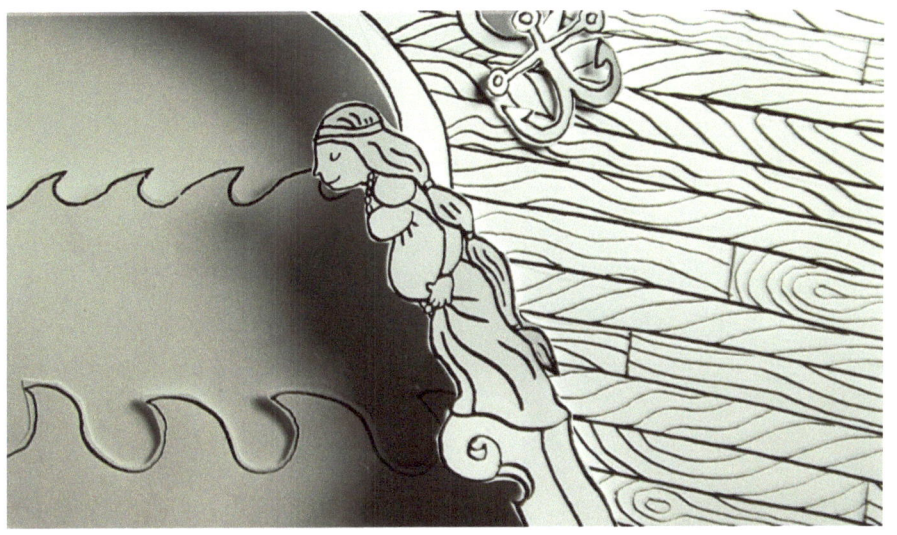

The Split House (animation production still), 2016

Annie Poon (b. 1977) USA

Some organizations the artist has worked with include: The Museum of Modern Art, Brigham Young University, MIT, The Museum of Art and Design, Mormon Artist Group, The National Gallery, the Brooklyn Academy of Art, the Next Wave Festival, PBS, CBS, New York 1, the New Museum, Nickelodeon, the Kidsfilmfest, the Chicago International Children's Film Festival, The Church of Jesus Christ of Latter-day Saints, The Brooklyn Museum, Bonneville Communications, The Madison Square Park Conservancy, Snow College, Carrot Books, Memorial Sloan Kettering Cancer Center, Fred Flare, and Pfizer.

Exhibition history:

2016 The Split House, Writ and Vision Gallery, Provo, Utah
 LDS Film Festival, Provo, Utah
 YoFi Film Festival, Yonkers, NY

2015 *Philip and Phoebe* by Anne Brandt (book illustration)
 Sketchbook Show, Writ and Vision, Provo UT
 Kidsfilmfest, Dumbo NYC
 Film Screening and Q&A, Museum of Modern Art NYC
 Dancing Dogs and Big Heads, Texas Tech University
 Animation Commission, MIT

2014 Sunstone Film Festival
 ONE Gallery, Dallas Tx.
 Go to Bed Ted (illustrated book)
 Summer Snow Faculty Exhibition, Ephriam, Utah
 Guest Teacher at Summer Snow art program, Ephriam Utah
 3 Private Animation Commissions, Bonneville Communications and Deseret Publishing

2013 Utah Biennial: Utah Museum of Contemporary Art
 Puppy's Super Delicious Valentine's Day Biscuits (iBook)

published by O Productions
Long Island Children's Film Festival, Guest Lecturer at Snow College, Ephriam Utah

2012 *Mormons at the Met* by Glen Nelson (book illustration)
Cuckoo clocks, Tavern on Jane
We Could Be Heroes, installation at Brigham Young University Museum of Art
Film Screening and Q&A at MoMA, New York

2011 National Gallery of Art, PBS Christmas Special, The Big Screen Plaza, Kidsfilmfest, LDS Film Festival, Provo Orem Word

2010 "*Slash*," Museum of Art and Design, Brigham Young University Art Gallery, The Martha's Vineyard Film Festival

2009 Long Island Children's Museum, The Chicago International Children's Film Festival, Kidsfilmfest at the New Museum, Brooklyn Heights Cinema, LDS Film Festival

2007 LDS Film Festival

2006 Museum of Modern Art, Nick Jr., Frederator Podcast, Saugatuck Children's Film Festival, Plum TV, Anthology Film Archives, Minneapolis St. Paul International Film Festival, Newport International Film Festival, Arizona Film Festival, Slamdance Film Festival, BamKidsFest

2005 *The Book of Visions*, a special limited edition published by Mormon Artists Group.
Chicago International Children's Film Festival, Nicktoons: The Nexttoons On Air Film festival, San Diego International Children's Film Festival, Lil' Longbaugh Film Festival, International Festival of Cinema and Technology, LDS Box Film Festival (Winner)

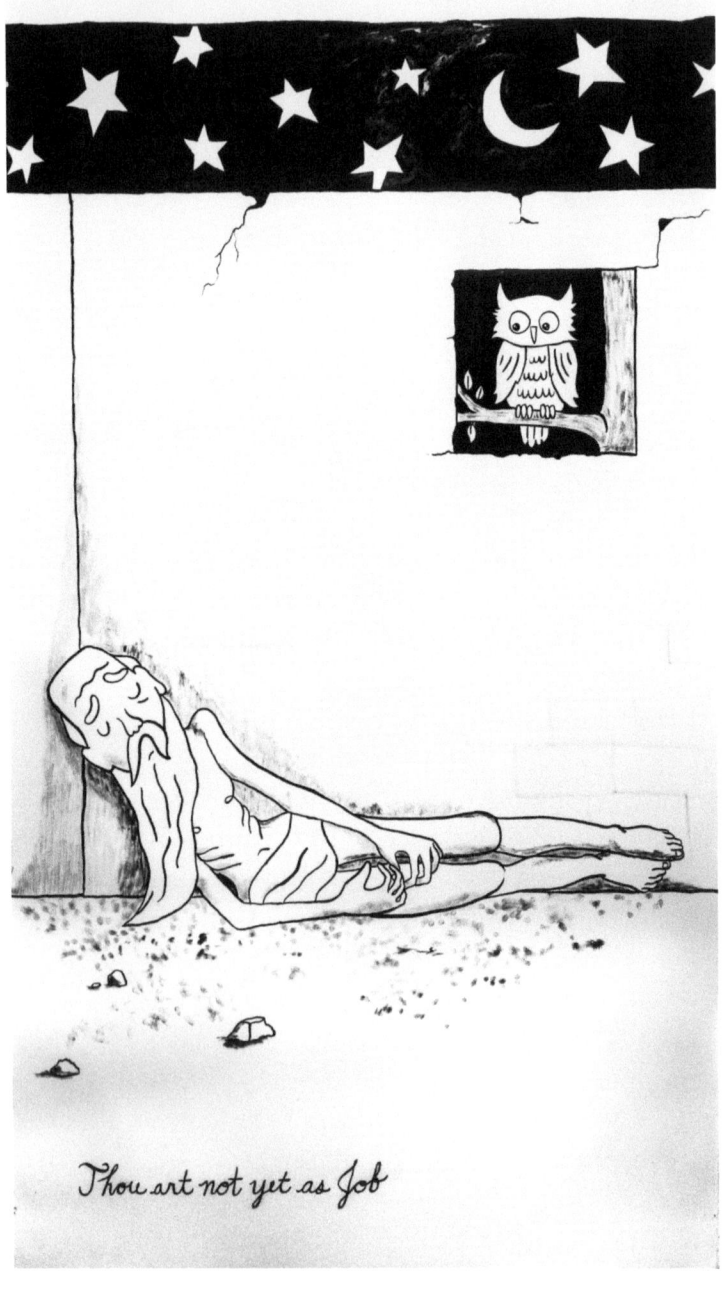

Thou Art Not Yet as Job, 2016

2004 Brooklyn International Film Festival, BAM Next Wave Film Festival

2003 Garden State Film Festival, NYC Video Theater, NYC Remote Lounge

Permanent collections:
Museum of Modern Art, New York; The Church of Jesus Christ of Latter-day Saints

Awards and Honors:
2013 Visiting Artist, Brigham Young University, Snow College

2009 Visiting Lecturer, Brigham Young University. 2009 Alumni Scholarship Committee, School of Visual Arts. 2007 Film of the Year, Association of Mormon Letters. 2005 Brooklyn International Film Festival Selection Committee 2005 KidsFilmFest Assistant director, School of Visual Arts Alumni Scholarship Committee, 2003 Alumni Award Scholarship, School of Visual Arts

Education:
BFA School of Visual Arts 2002

Writings on Art include:
(Books) *Gem Painting: The Art of Ilya Schar*. Books Press, California 2007
(Articles) "Life's Little Lessons by Julie Karabenick," *NYArts Magazine*, Jan/Feb, 2005 "Ilya Schar Returns Glamour to Broadway," *NYArts Magazine*, Nov/Dec, 2004 "City Sketchbook: The Art of Carol Caputo," *NYArts Magazine*, Sept/Oct 2004, "Aerial View: The Art of Lance Dehne," *NYArts Magazine*, July/August 2004, "Buzz Clips," *NYArts Magazine*, Sept/Oct 2004.

Filmography:
The Split House (2016)
Animated short
5 min.
Synopsis: A woman seeks relief from the chaos inside her mind. With the help of a friend she transforms into an owl and tumbles into an dark uncharted mental chasm to explore her subconscious.

MIT Commission (2015)
1 min.
A scientific depiction describing a DNA function as it relates to memory and Alzheimer's.

Daisy Daddy (2015)
Animated short
2 min.
Synopsis: Puppy buys a bunch of wilting daisies and takes them out for a grand adventure. But how long can the delicate flowers play before their tiny energy is spent?
Broadcast History: 2015: Kidsfilmfest; 2016: LDS Film Festival

Forgiveness (2014)
1 min.
A film illustrating a quote affirming that forgiveness, though great in value, is a free gift to all that would bestow it.

Walk as He Walked (2014)
1 min.
A film illustrating President Thomas S. Monson's quote encouraging viewers not to walk where Jesus walked but as he walked.
A commission by Bonneville Communications

Maid Arise (2014)
1 min.

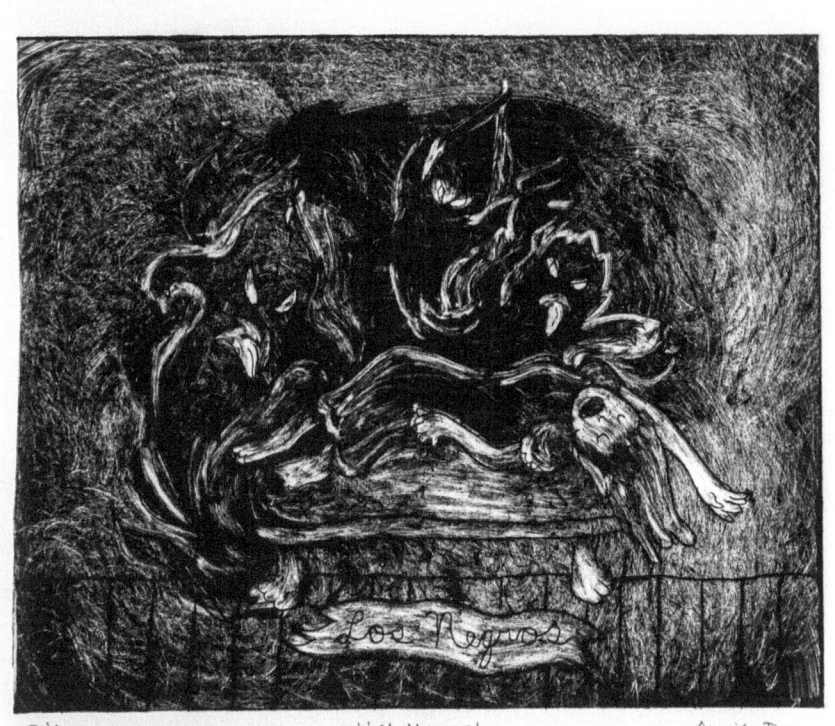

Los Negros, 2016

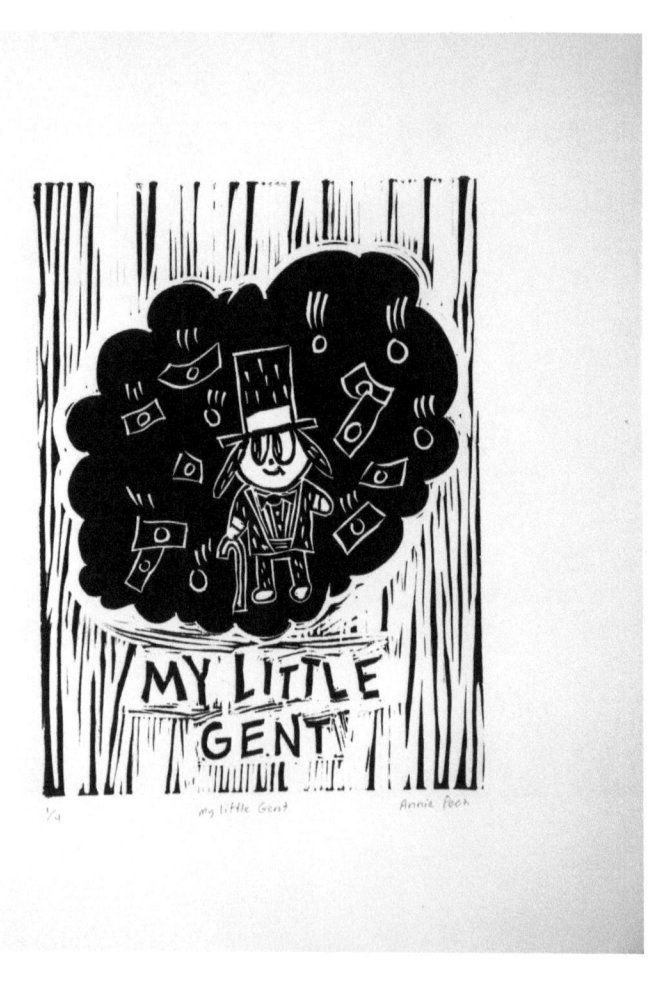

My Little Gent, 2016

Talent, 2016

The daughter of Jairus lays in the home dead until Jesus ressurects her and reunites her with her father.
A commission for Bonneville Communications.

When You Are in the Country Alone (2014)
2 min.
A cautionary warning to all those who would seek enjoyment visiting the countryside. Danger lurks in every activity.

Psychedelic Alan (2014)
1 min.
A stop motion fashion animation starring Alan Cumming. Features psychadelic patterns and photos by Kah Poon.
Broadcast History: Spirit and Flesh Magazine Online

Past Perfect (2013)
1 min.
A fashion video based on a sci-fi fashion shoot by photographer Kah Poon.
Broadcast History: Spirit and Flesh Magazine Online

Hippie Love (2013)
1 min.
A fashion video celebrating looks inspired by the sixties. Footage drawn from a shoot by Kah Poon. Features model Jennifer Pugh.
Broadcast History: Spirit and Flesh Magazine Online

The Shiny Bicycle (2013)
2 min. 30 sec.
A little boy gets a shiny new bicycle for his birthday. But the neighborhood bikes are all red. He decides on a plan for fitting in and learns a lesson about correcting his mistakes.
Broadcast History: Mormon Messages on the Mormon Channel

Oh Puppy! (2011)
1 min.
Soundtrack by Annie Poon
Synopsis: Once upon a city on a hot summer day, Puppy landed in New York and he's here to stay! Come rock on with Puppy and don't blink during this short rap music video.
Broadcast History: 2011, The Big Screen Plaza, Kidsfilmfest

Scripture Skit (2010)
Animated rap music video
2 min.
Synopsis: A mother laments her ne'er-do-well teenage sons, the biblical characters Samson, David, and Goliath. "They'll go to heaven or hell, we mothers gotta do well." This video takes its cues from female no budget rap videos on YouTube.
Broadcast History: 2010, Brigham Young University art gallery

A Day of Life (simple) (2010)
30 sec.
Synopsis: A brief poetic musing on the pleasures of a simple day.
Broadcast History: Kidsfilmfest, 2010

A Day of Life (fancy) (2010)
30 sec.
Synopsis: A brief poetic musing on the pleasures of a simple day.

Die Wicked Die (2009)
Animated series of four shorts
30 sec.
Synopsis: Scriptural bad boys meet wicked ends. The teenage style doodlings and a punk rock track meet one-to-one deadly confrontation.
Broadcast History: BYU Museum of Art 'We Could Be Heroes' exhibit, 2011.

Snowflakes in Love (2009)
Animated short
2 min.
Synopsis: Two little snowflakes flirt as they drift towards the ground. Holiday bells, a fox, and snuggling snowmen bring the holiday spirit. Commissioned by Fred Flare, Inc.
Broadcast History: FredFlare.com website

Puppy's Super Delicious Valentine's Day Biscuits (2009)
Animated short
3 min.
Synopsis: Puppy Decides to bake something sweeet, hoping to win the heart of Miss Duck on Valentine's Day. Her unexpected reaction and ingenuity lead to a creative conclusion.
Voice Talent: Puppy - Dash Nelson
Duckie - Katherine Godwin
Broadcast History: 2011; Kidsfilmfest, 2009; Long Island Children's Museum, The Chicago International Children's Film Festival, KidsFilmFest at the New Museum and at the Brooklyn Heights Cinema, 2011 National Gallery of Art; 2014: Long Beach Children's Film Festival

Annie's Circus (2008)
Animated short
4 min.
Music video
Music by: Coldplay (with usage rights granted)
Synopsis: A woman wanders the streets of New York, preoccupied with thoughts of mortality.
Broadcast History: 2009; LDS Arts Festival

Me Good Me Bad (2007)
Animated short
3 min. 30 sec.
Score by Peter Pezzimenti
Synopsis: After eating a forbidden berry, the young protagonist decides

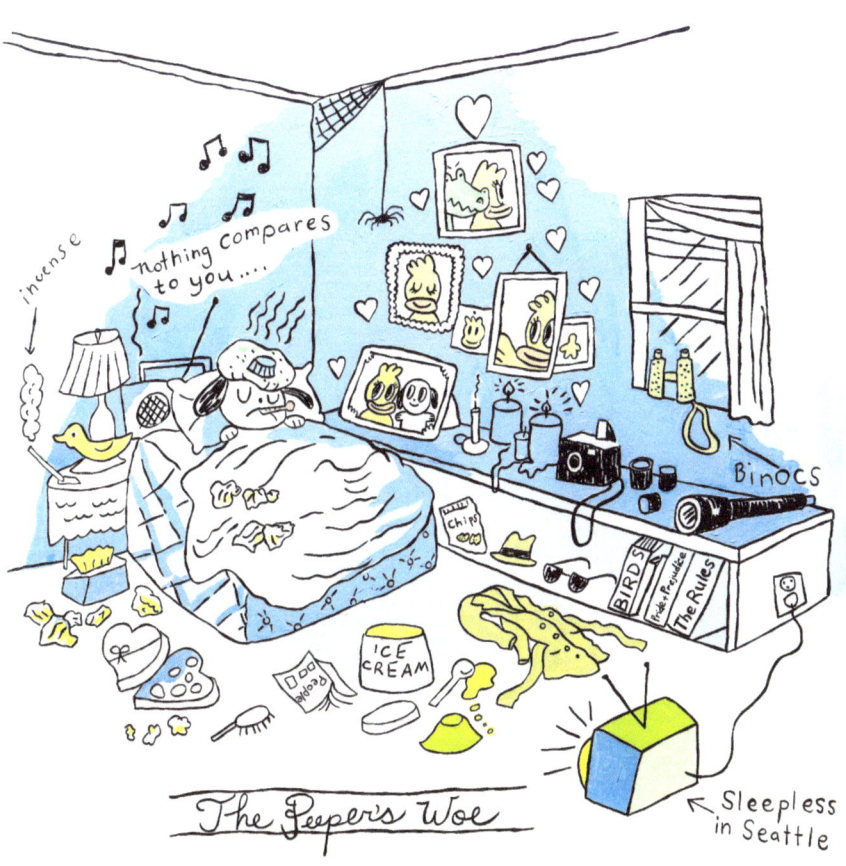

The Peeper's Woe, 2016

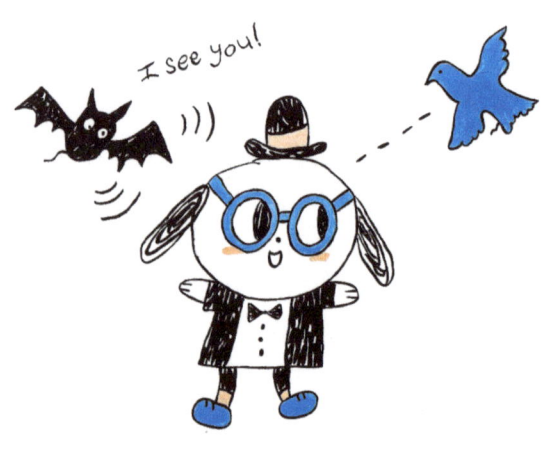

Ecolocution, 2016

to set out and discover what wonders lie beyond her island of innocence. (Continues in comic book form.)

Gastrulation (2007)
2 min.
A flash animation created in collaboration with the genetic research department of Sloan Kettering Memorial Cancer Center of New York. Depicts the pre-embryonic development of the mouse.

The Book of Visions (2005)
Animated short
11 min.
Score by Annie Poon with additional music by Peter Pezzimenti
Synopsis: An elderly gentleman discovers a mysterious volume, "The Book of Visions." In this stop-motion animation, the historical figures Joan of Arc, Sioux Indian chief Black Elk and American prophet Joseph Smith spring to life as tiny paper cut-outs in a mysterious book. Commissioned and published by Mormon Artists Group.
Broadcast History: 2011 'Provo Orem Word' online magazine. 2007, LDS Film Festival; 2006, Slamdance Film Festival January, Arizona International Film Festival, Anthology Film Archives New Filmmakers Series.
Awards: 2007, Mormon Arts and Letters Film of the Year

Runaway Bathtub (2004)
Animated short
3 min.
Score by Joshua Williams, voice by Maddie Williams
Synopsis: Bathtime turns into an adventure when the tub floods and two little girls are carried out to sea! They meet fishy friends and sharky foes and even have a rainwater tea party.
Broadcast History: 2009, The Long Island Children's Museum, The New Museum, Brooklyn Heights Cinema (KidsFilmFest); 2006, Museum of Modern Art, Plum Television (Boiing Program), Nicktoons Podcast, Minneapolis-St. Paul International Film Festival, Newport International

Film Festival, BAM Kidsfirst Festival, East Lansing Childrens' Film Festival; 2005, Chicago International Childrens' Film Festival, Nicktoons: The Nexttoons Film Festival, LDS Box Film Festival (winner), Lil Longbaugh film festival, San Diego International Childrens' Festival, International Festival of Cinema and Technology, Portland International Short Shorts Festival; 2004, Brooklyn International Film Festival 2003

Paper Doll, 2004
Animated short
4 min.
Music by Annie Poon, Kirsten Heming, and Nathan Scruggs
Synopsis: A paper doll undergoes transformations of dress and scenery. She challenges the viewer with her cryptic questions and pithy sayings.
Broadcast History: 2010; The Museum of Art and Design: SLASH- Paper Under the Knife exhibit, 2004; "Conversions" gallery exhibition, NYC

Christmas Tree (2003)
Animated short
2 min.
Sound by Annie Poon
Synopsis: It's time to decorate for the holidays! Watch a pair of hands unpack a tiny paper trunk and hang teeny stockings with care.
Broadcast History: 2010, The Museum of Art and Design, SLASH- Paper Under the Knife exhibit, The Martha's Vineyard Film Festival; 2009, The New Museum; Family Programs, www.fredflare.com

Subway Story (2003)
Animated short
5 min.
Music by Duke Curry ©Paul Desmond
Synopsis: A subway trip becomes a groovy adventure when the humans get off and the animals get on! Climb aboard for a jazzy ride. You'll be swingin with monkeys and singin with the birds.
Broadcast History: 2006, Jackson Heights Childrens Film Festival; 2005, Lil' Longbaugh Film Festival.

Tis the Night of Halloween (2002)
Animated short
1 min. 30 sec.
Music by Annie Poon and Michael Greenwald
Vocals by "The O"
Synopsis: A song to be sung while trick-or-treating. Ghosts and goblins party in the graveyard and the haunted house. All the host of Halloween is stirring on this spooky night!
Broadcast History: 2009, The Museum of Art and Design: Slash- Paper Under the Knife; 2003, Garden State Film Festival.

In Love (2002)
Animated short
20 sec.
Synopsis: A romantic interlude. Two lovers kiss for 20 seconds.

The Roly Poly Pudding (2002)
Animated short
3 min.
Adapted from the story by Beatrix Potter
Music by Peter Pezzimenti
Voices by Annie Poon
Synopsis: Tom Kitten's curiosity gets the best of him when he climbs up the chimney. He is soon lost in the walls of his house. Oversized rats kidnap him and tie him in knots. Who will rescue him?
Broadcast History: 2003, NYC Video Theater.

Haircut (2002)
Video essay
5 min.
Synopsis: A comic essay on beauty and the pursuit thereof. A young woman undertakes to improve her self image. She makes a rash decision and invites her little sister to chop off her locks. Then impulse meets reality in the mirror's reflection.

Exhibition checklist

El Sueño (2016)
drypoint etching
image size: 8" x 10"; paper size: 11.5" x 15"
edition: 3

Los Negros (2016)
monoprint
image size: 8" x 10"; paper size: 14.5" x 15"
varied edition: 3

Storm Clouds (2016)
copperplate etching
image size: 8" x 6"; paper size: 13" x 13.5"
edition: 3

Lightning and Rain (2016)
monotype
image size: 12" x 9"; paper size: 15" x 11.25"

My Little Gent (2016)
linocut
image size: 9" x 12"; paper size: 15" x 18.25"
edition: 4

The Peeper's Woe (2016)
acrylic on canvas
30" x 30"

Talent (2016)
acyrlic on canvas
16" x 20"

Ecolocution (2016)
acrylic on canvas
20" x 20"

Mansfield Park (2015)
acrylic on paper
14.5" x 18.25"

The Story of My Life by Hellen Keller (2015)
acrylic on canvas
14.25" x 18.25"

Gandhi: An Autobiography (2015)
acrylic on paper
14.25" x 18.25"

To Kill a Mockingbird (2015)
acrylic on paper
14.25" x 18.25"

The Oak Wood (2015)
acrylic on paper
22" x 28"

Hunt Piece (2015)
acrylic on paper
22" x 28"

Thou Art Not Yet as Job (2016)
india ink on paper
14.5" x c. 90"

The Hiding Place (2011-2015)
mixed media
20" x 20" x 16", variable dimensions

A Rubber of Whist (2011-2015)
mixed media
16" x 18" x 16", variable dimensions

Puppy Maze (2015)
print
11" x 17"
open edition, unsigned

The Split House (2016)
(See following pages)

The Split House (2016)
Stop-motion animation, 5 min.
edition: 1 (unique)

 a. box (facing page, top)
 wood, acrylic paint, felt, ribbon
 11" x 15" x 3"

 b. film archives (facing page, bottom)
 comprehensive 66-page portfolio of original stills, storyboards,
 drawings, and notes for The Split House
 paper size: 8.5" x 12"

 c. film on flash drive (facing page, top)
 box: 3" x 2" x 1"
 flash drive with painted Yeti

 d. owl soft sculptures (2) (facing page, top)
 cotton, polyfill, hand-sewn and embroidered
 4" x 5" x 1"

 e. etchings (3) (below, left to right)
 The Hole (2016)
 Bat Cave (2016)
 Gentle Hands (2016)
 each: copperplate etching, 4" x 6" (paper size: 8.5" x 11")
 edition: 1 (unique)

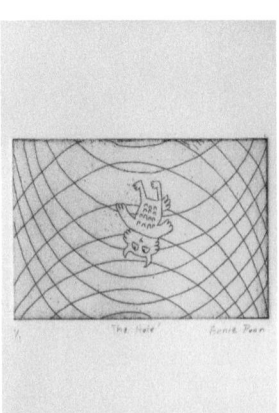 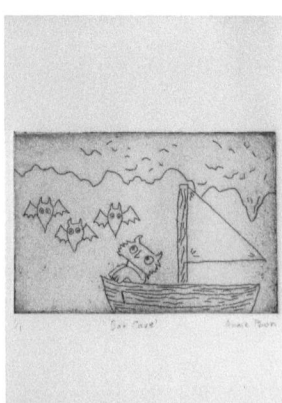 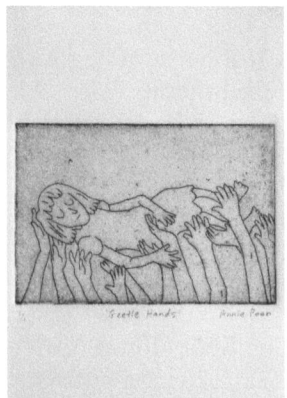

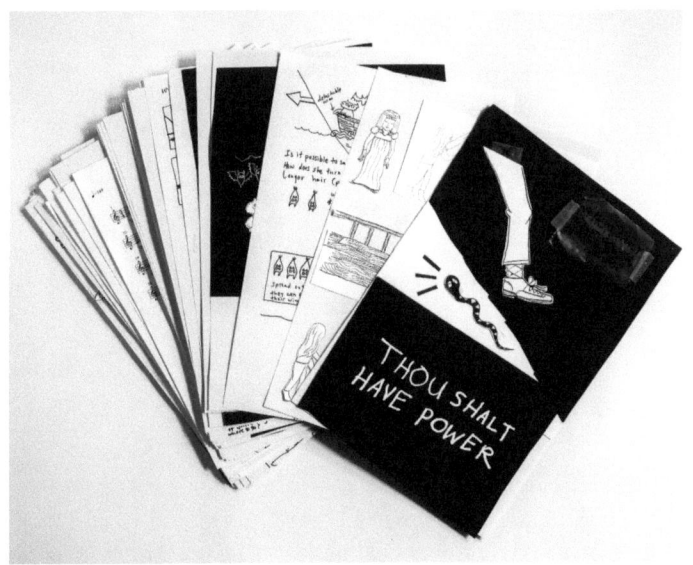

The Hiding Place, 2011-2015

www.ingramcontent.com/pod-product-compliance
Lightning Source LLC
Chambersburg PA
CBHW040846180526
45159CB00001B/336